THEN & NOW

WILMINGTON

WILMINGTON

Susan Taylor Block

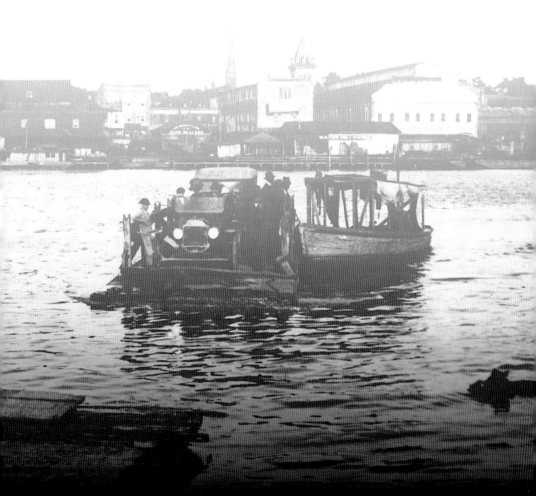

Library of Congress control number: 2007928719

Published by Arcadia Publishing
Charleston SC, Chicago IL, Portsmouth NH, San Francisco CA

Printed in the United States of America

For all general information contact Arcadia Publishing at:
Telephone 843-853-2070
Fax 843-853-0044
E-mail sales@arcadiapublishing.com
For customer service and orders:
Toll-Free 1-888-313-2665

Visit us on the Internet at www.arcadiapublishing.com

COVER AND TITLE PAGE: William Jones and his son Abraham ran the Durant family's ferry business for decades. William's grandson Clarence also rode the ferry as a boy, lowering the blinds on the *Ray* (on right) when it rained. Later, Clarence Jones became a master gardener and horticulturist at Orton Plantation.

CONTENTS

ACKNOWLEDGMENTS

A number of individuals contributed to this publication. Arcadia Publishing editor Jim Kempert, Cape Fear Museum director Ruth Haas, Rachel Pace, Sue Miller, Eleanor Wright Beane, Janet K. Seapker, Melva Pearsall Calder, Barbara Rowe, Edward F. Turberg, Joe Sheppard, Dr. Chris Fonvielle, Tony P. Wrenn, Diane Cashman, Beverly Tetterton, Dr. James Rush Beeler, Nancy Beeler, David Sprunt, Clarence Jones, Merle Chamberlain, Hugh MacRae II, Jerry Cotten, Dr. Wilson Angley, Steve Massengill, Anne Russell, Gene Merritt, Isabel James Lehto, Walter Hunt, Gibbs Willard, Jean McKoy Graham, Henry B. Rehder, John H. Debnam, Mary Wootten, Brooks N. Preik, Jessie Leigh Boney, Tony Rivenbark, Rebecca Laymon, Joe Capell, Elaine Henson, Calvin Wells, and the late Emma Woodward MacMillan, who earlier wrote a book, *Wilmington's Vanished Homes and Buildings*. The archives of The Lower Cape Fear Historical Society and the local history materials at the New Hanover County Public Library have yielded many facts. William M. Reaves's newspaper clipping files deserve special praise.

I would like especially to thank Suzanne Nash Ruffin, who originally edited *Along the Cape Fear* and *Cape Fear Lost*; Diane Cobb Cashman, who has always provided me with facts and writing advice; Ann Hewlett Hutteman, who reviewed the manuscript; and my husband Frederick L. Block, for his perpetual and enthusiastic support of my work.

INTRODUCTION

Notwithstanding exceptions, usually when fine old buildings are replaced it's a case of stainless steel strips taking the place of sterling filigree. Sometimes there is simply no replacement, but only a vacant lot filled with weeds and litter. Occasionally a historic vista simply evolves to feature a scene inconceivable early in the life of an old American city.

There are many reasons good buildings disappear. Sometimes real estate taxes overburden the owner. At times fire, flood, or gross negligence dismantle brick-and-mortar jewels. But often the problem is simply a failure to recognize distinction. The owner lets trendiness, dreams of ultimate functionality, or an aversion to upkeep blind him or her to the rich wonders of antique constructions.

Wilmington, North Carolina, founded 1739–1740, is still home to many handsome structures from the past, as well as some good new buildings. But like many Colonial-born municipalities, one can only imagine what it would look like today if all the cottages, houses, gardens, and diminutive palaces remained.

Wilmington, from Arcadia Publishing's Then & Now series, serves to foster both the appreciation of our past and the careful guardianship of our future. A companion book, *Cape Fear Lost*, offers many additional facts and stories.

S. T. B.

STREET SCENES AND RIVER SCENES

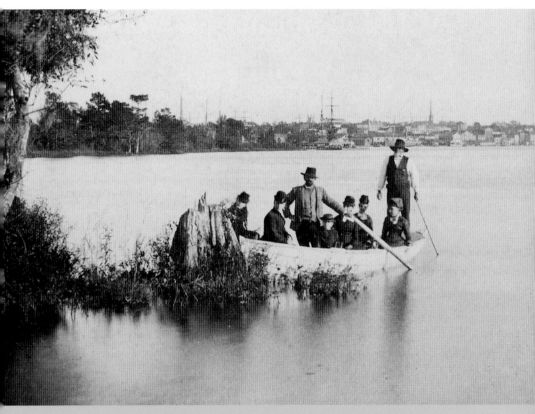

What's there not to like about a city set upon a river, a city that glows with a special kind of light, a city beset with natural beauty? Today miles of film shot for television shows and motion pictures include street and river scenes of Wilmington, North Carolina. But for those of us who had the good fortune to grow up here, that's no surprise. We knew all along that we lived in a very special place. For the rest of the world to know is merely satisfaction. (Photo of an 1880 outing from *Along the Cape Fear*.)

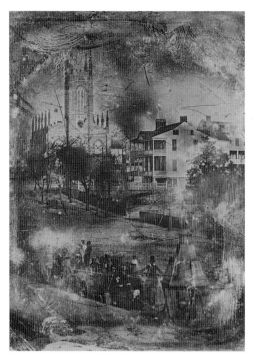

Dating from 1847, this is the first known photograph of Wilmington and the earliest outdoor image of North Carolina. The photographer, perhaps John Plumbe Jr., captured the 1839 St. James Church building with all its finials intact, the Burgwin-Wright House, the globe of a handsome street lantern, and an animal-drawn conveyance used to transport guests from a nearby hotel to the train station. Today the church, Burgwin-Wright House, and 1842 St. John's Masonic Lodge at 125 Market Street, from which this photo was taken, all survive. (Courtesy Amon Carter Museum; Fort Worth, Texas.)

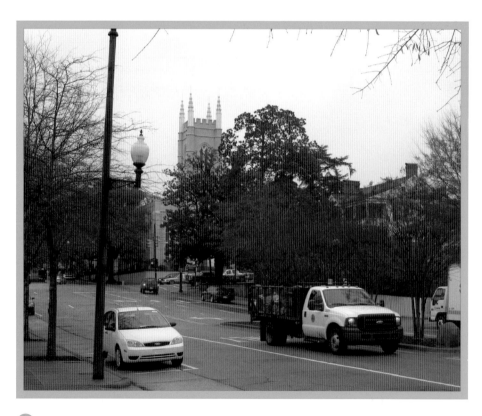

STREET SCENES AND RIVER SCENES

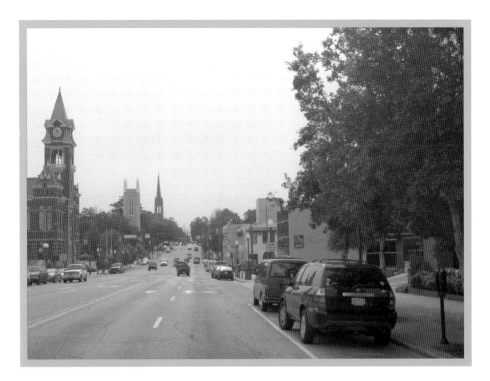

The anachronistic photograph below, taken by historian Louis T. Moore at the 1928 Feast of Pirates parade, showcases Wilmington's Third Street and sets the tone for looking back.

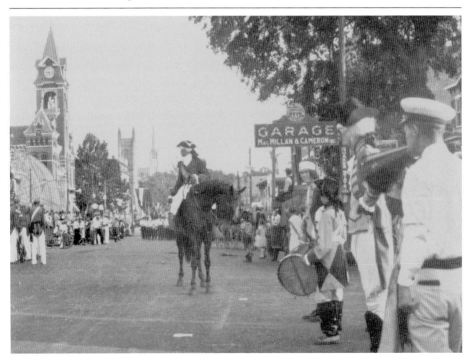

Ties and millinery were required dress for this *c.* 1898 picnic at Hilton, the live oak studded area just north of downtown Wilmington. Hilton, named for 17th century explorer William Hilton, was later the site of baseball diamonds, a rudimentary golf course, shooting range, and the first civic playground for children. Today baby boomers remember Hilton fondly as the home of the moss draped "World's Largest Living Christmas Tree."

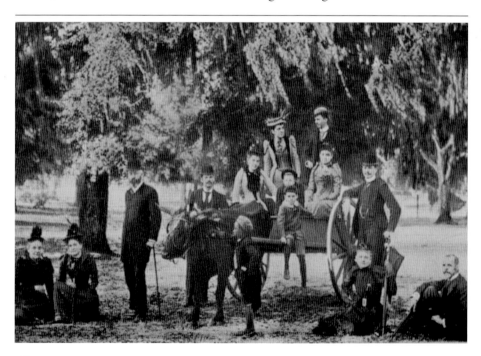

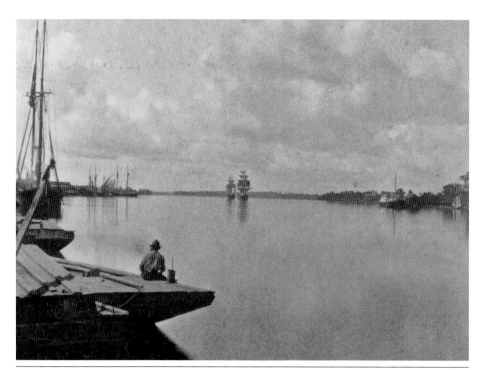

Both the wonders of nature and of man capture the attention of this lad, *c.* 1880. Frozen in time by the photography firm operated by Charles W. Yates and Alexander Orr Jr., this image captures romantic sailing ships and industrial steamers. Today the Cape Fear is being rediscovered as a thing of beauty and an avenue of recreation. The 1969 Cape Fear River bridge spans two counties that are now becoming increasingly comparable in real estate values.

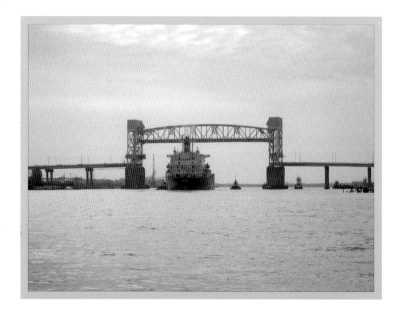

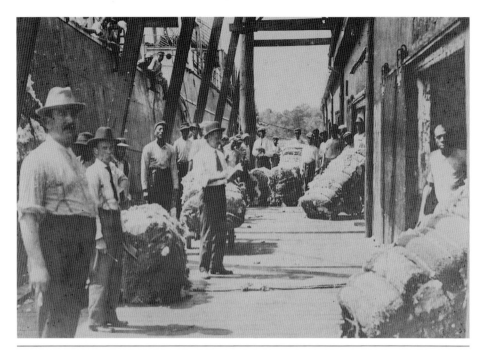

Steamers like this one that docked in Wilmington about 1918 were loaded day and night at the Alexander Sprunt and Son's Champion Compress warehouse wharf. The Sprunt enterprise kept regional farmers afloat and, through the philanthropy of compress owner James Sprunt, maintained numerous local charities and a sizable medical missionary station in China. Today tourists and meandering locals dock themselves on Wilmington's Riverwalk benches. (Special Collections, Duke University.)

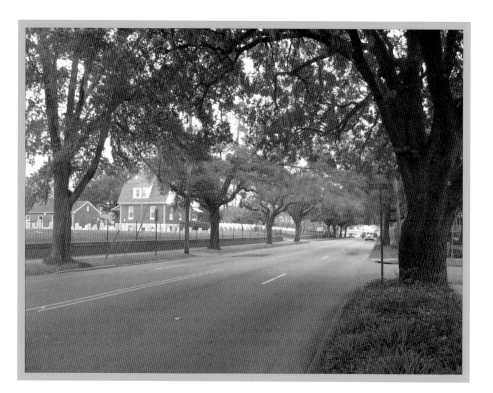

During the 19th century, there was more than just one "Shell Road," the name usually associated with Wrightsville Avenue during horse-and-buggy days. This 1900 image was identified as "Shell Road," but is better known today as Market Street. The building on the left is presently the office of Wilmington National Cemetery at 2011 Market Street. Today this section of Market Street features "squeeze-me-tight" lanes created over 20 years ago to accommodate increasing traffic and save bordering trees.

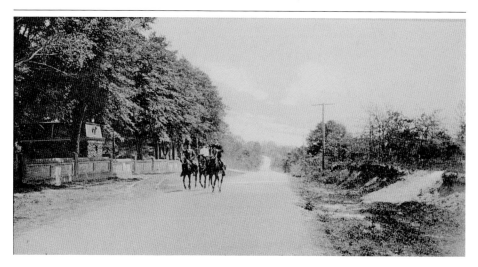

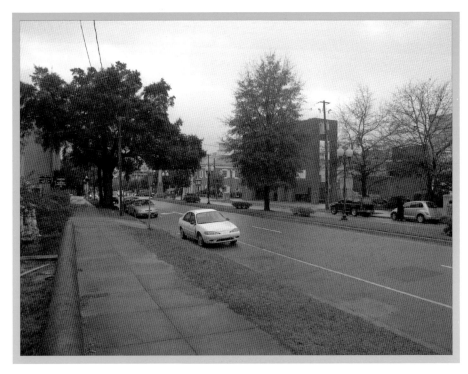

The photo below was taken from Claude Howell's balcony, looking northwest from Fifth and Market, *c.* 1921. The two gracious homes in the foreground, the McClammy and Beery houses, have long since bit the dust. Today the contemporary building erected by New Hanover County government has been purchased by First Baptist Church. Renamed the Joann Carter Harrelson Center, the space houses various non-profit organizations.

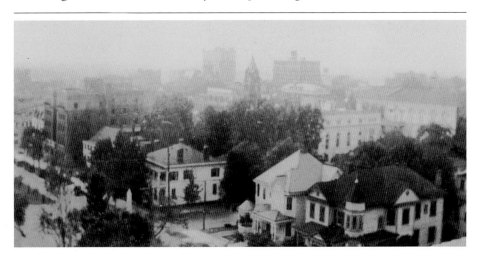

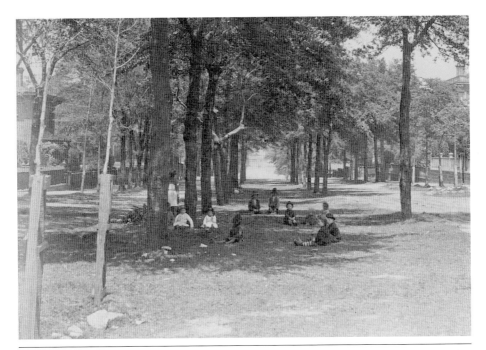

The photograph above might look like a park, but this is South Third Street, looking north near the intersection at Dock, *c.* 1880. The chimney and fence of the Edward Kidder House can be seen on the right. A portion of the MacRae-Dix House is visible on the left. The easy going days of Wilmington's downtown thoroughfares have been gone for decades. The photo below depicts a rare break in traffic, as vehicles usually fill the road today. Wilmington continues a pattern of explosive growth that began in the late 1980s—and tourists from home and abroad increasingly seek out its charm and beauty.

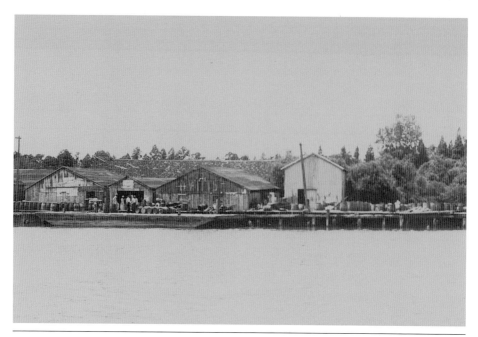

Eagles Island, pictured above in 1920, was named for Richard Eagles, who purchased the land in 1739. It has been a plantation, a thoroughfare for George Washington, and the site of Revolutionary gunfire. In 1961, Eagles Island became home to the U.S.S. *North Carolina*, a battleship memorial that has now received over 11 million visitors. The TV show "One Tree Hill," currently in its fifth year of local production, includes many outdoor scenes on Eagles Island, but the Wilmington waterfront, seen as background, is the enduring star.

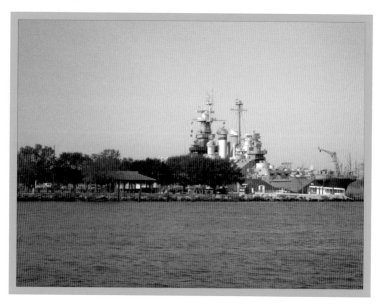

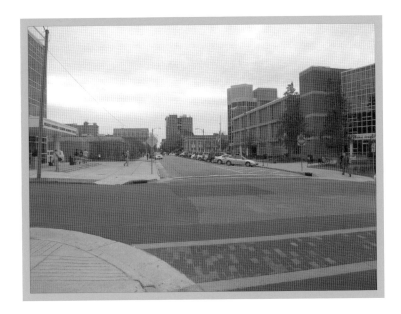

The photograph below shows the view looking south on North Front Street in the late 1930s when this portion of downtown was Atlantic Coast Line railroad territory. When lunchtime arrived, the sidewalks were so jammed with ACL employees that sometimes people would have to walk in the street. A solid bit of the grand old Union Station is visible on the left and the expansive Atlantic Coast Line office buildings sit on the right. Today Cape Fear Community College real estate holdings dominate the scene.

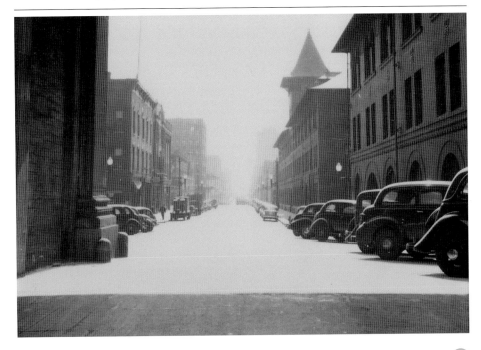

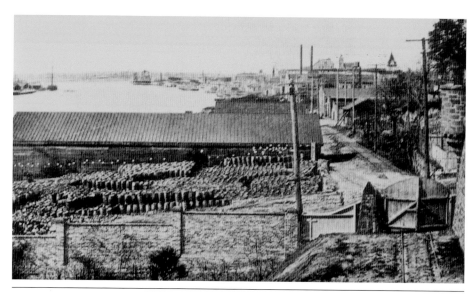

The photograph of a naval store yard (above), stocked with tar and resin, was taken *c*. 1895 from the west side of the Governor Dudley Mansion. From the vantage point of a stairway that no longer exists, the railway is visible across James Sprunt's land. He gated the Nun Street side, but furnished a key to the railroad conductor. Today the space pictured above is filled with Chandler's Wharf—shops and restaurants housed in historic settings. Chandler's Wharf was the brainchild of leading preservationists Elizabeth and Thomas H. Wright. (Below photo by author.)

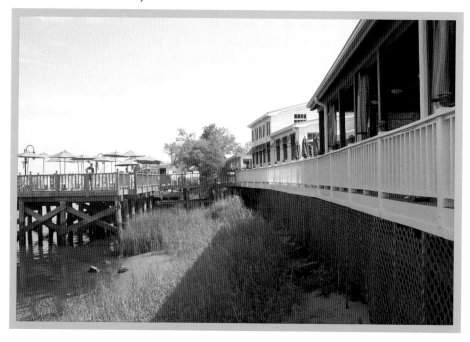

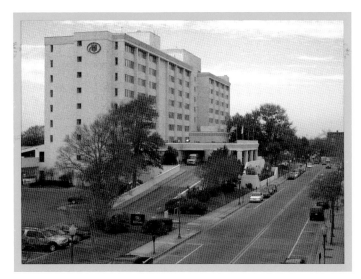

The Worth and Worth wharf, pictured below *c.* 1880, was on the river side of Water Street between Grace and Walnut Streets. They shared the wharf with Alexander Sprunt and Sons. As agents of the Cape Fear Steamboat Company, Worth and Worth built the river steamers *A.P. Hurt*, *Flora McDonald*, and *Governor Worth*. The Hilton Wilmington Riverside Hotel, built in 1968, was the first modern business to take advantage of the river view. Wilmington native Hugh Morton helped recruit the inn, first known as the Timme Plaza. It was a perfect place to view another attraction he helped bring to Wilmington: the U.S.S. *North Carolina*.

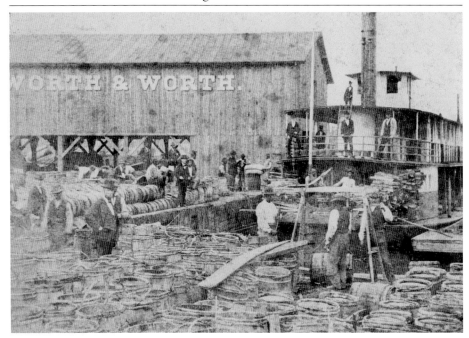

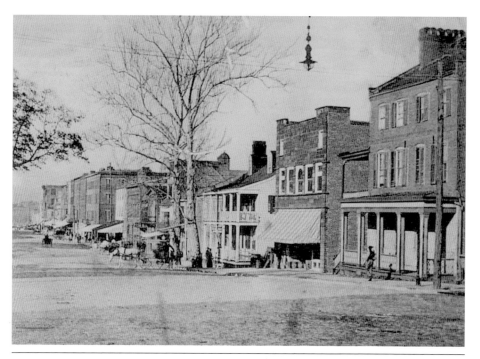

The north side of Market Street, from Third to Second, consisted of solid buildings, c. 1901. Mrs. Potter's Boarding House is third from the right, with a double porch. At one time there were as many as 50 boardinghouses in Wilmington, most of them downtown. Now apartments that rent for surprising figures have taken the place of boarding houses—and parking decks proliferate.

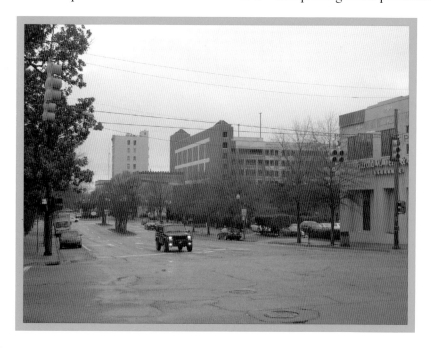

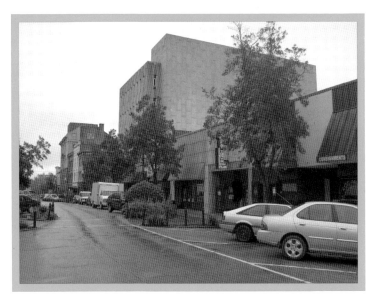

Looking south on North Front Street from Chestnut (below), the two-story gingerbread veranda of the Orton Hotel gives a sense of its elegance. The 100-room inn provided Wilmington's five-star lodging for decades. The streetcar line intersection at Front and Princess Streets was an important one: Boarding the eastbound cars put you on a breezy ride to beautiful Wrightsville Beach. Today storefronts stand where the likes of Thomas Edison walked the polished floors and plush rugs of the Orton Hotel—and the streetcar system with its eco-friendly features seems another treasure lost.

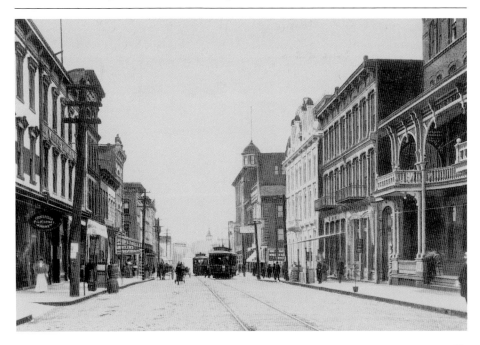

Coordinated landscaping enhanced the rear lawns of the Hugh MacRae House, on the left below, and the Agnes MacRae Parsley House, on the right. Mr. MacRae and Mrs. Parsley, who were also brother and sister, apparently employed the same gardeners for both yards, which ran through to Princess Street. The Parsley stable, a 1906 English-style, two-story structure designed by Henry Bonitz, can be glimpsed on the right. It was built of Borden brick, and had limestone trim and a slate roof. Today asphalt has replaced the garden.

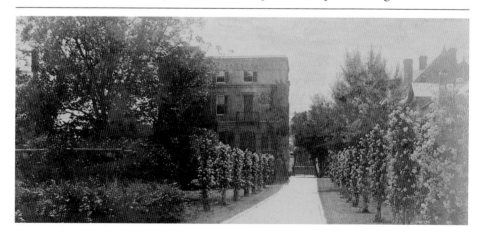

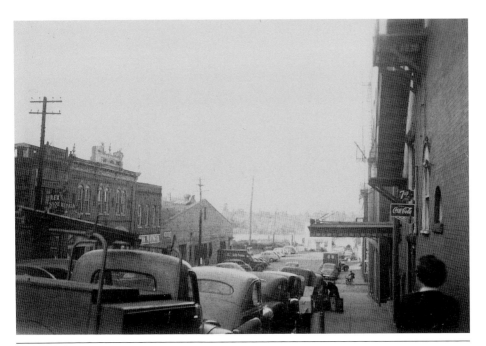

In the late 1940s, the foot of Grace Street was still home to the Atlantic Fireboat House, and wholesale businesses dotted the landscape. From this vantage point today, the parking deck and Hilton Hotel loom large. The property on the right is part of the Cotton Exchange complex, a model of adaptive use engineered by Wilmington businessmen Joe Reaves and Mal Murray.

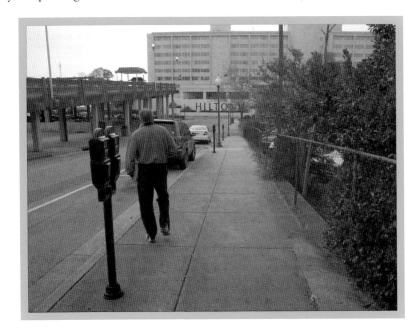

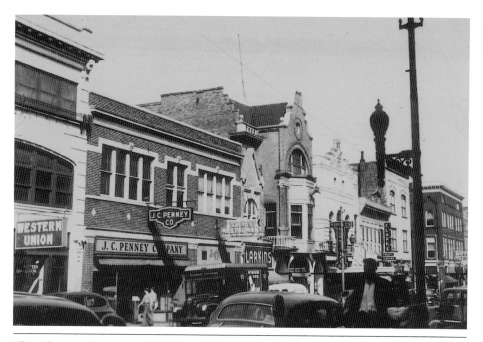

Though many businesses left downtown for the suburbs years ago, Wilmington's oldest neighborhood has experienced a rebirth. Tourists, college students, movie industry employees, young professionals, and a host of other types mingle in coffee shops, restaurants, and bars located throughout the downtown area.

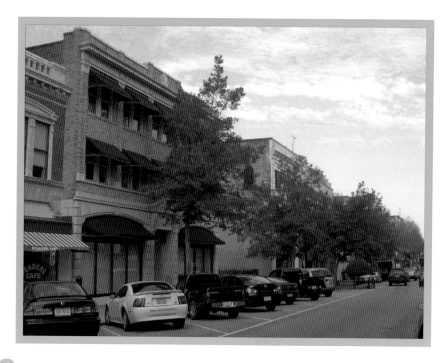

These idle riverfront buildings may look pretty tame in the 20th century photograph below, but during the 19th century, Water Street was famous not only for its serious maritime businesses but also for its dance halls, rooming houses, and other sailor oriented establishments. As late as the 1930s, Claude Howell said, "I suppose you could find anything on Water Street." Today the U.S. Coast Guard Station occupies this stretch of prime real estate.

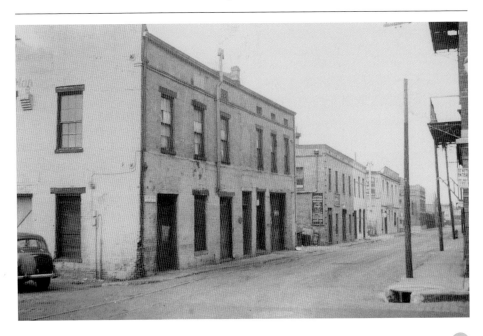

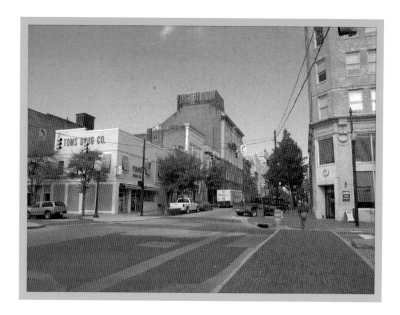

The northeast corner of Front and Market Streets was the business address of merchant John Dawson until January 1840, when it and many other buildings burned in the famous "Dawson Fire." It was replaced by the building on the right above. After Dawson died in 1881, druggists J.K. McIlhenny and, later, William H. Green and Company occupied this cozy corner building at the intersection of Front and Market Streets. However, in 1910, it was razed to make room for the much taller Atlantic Trust and Banking Company Building seen in the right foreground. The slender building's non-conforming height, nine stories, has long been a subject of discussion. "Somebody thought Wilmington was gonna' get mighty big," said one old-timer.

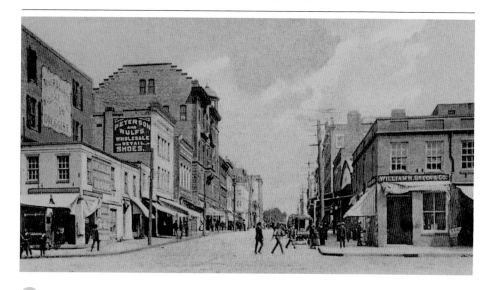

STREET SCENES AND RIVER SCENES

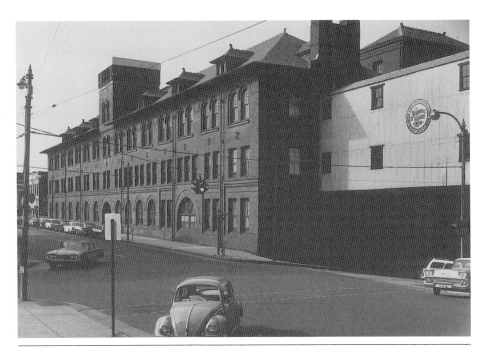

By 19th-century standards, this Atlantic Coast Line office building was as generic as its name. Building A was one of several imposing railroad structures that dominated the west side of North Front Street, beyond Walnut, for 70 years. Though it was built in 1889, the tower was not added until 1900. Interior décor was minimal—usually heavy wood desks and chairs, and big ACL calendars as wall art. But the corporate result was major: By 1950, the Atlantic Coast Line Railroad owned over 5,500 miles of track. Currently Cape Fear Community College buildings fill the space.

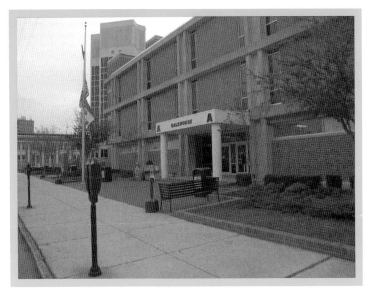

Photographer Rufus Morgan captured the scene below in 1873 when turpentine distilleries and tar and rosin storage were big business in Wilmington. Forests full of soaring ancient trees also provided rich heart-of-pine lumber that was used in local construction and shipped to northern states and the West Indies. Though the scene changes perpetually, it always seems to invite an extra look.

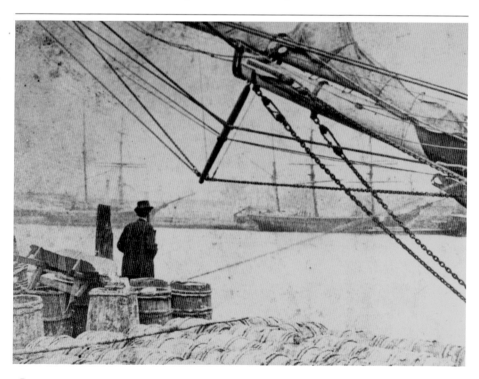

HOME LIFE

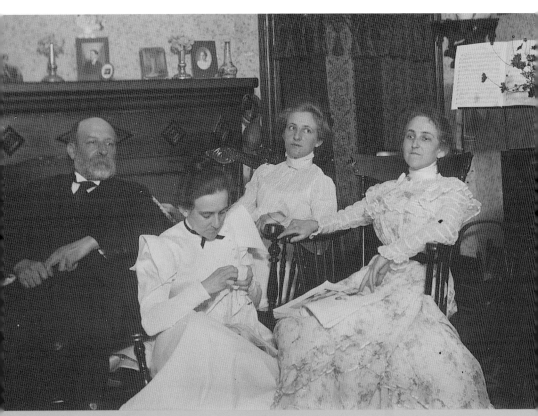

Wilmington was once a city of many grand old houses perched proudly on handsome tree-lined streets. Taken together, the residences formed a mosaic of diverse features—cupolas, turrets, brackets, balconies, stained glass windows, and castle-like effects. Built for breeze, they seem quirky today with their wide halls that go from front door to back door, their vents, and their windows that virtually stretch from floor to ceiling. Studying them gives us a bubble-glass window on the past. (Photo of Howell family members from *Along the Cape Fear*.)

The Hill-Wright-Wootten House at 11 South Third Street was constructed well before 1799. The four-story house served as home to North Carolina senator, banker, and physician John Hill; renowed attorney William A. Wright who conducted Wilmington and Weldon Railroad board meetings here; and the Rev. Edward Wootten, an Episcopal priest. In 1951 St. James Church purchased the house and subsequently razed it as part of an "expansion program."

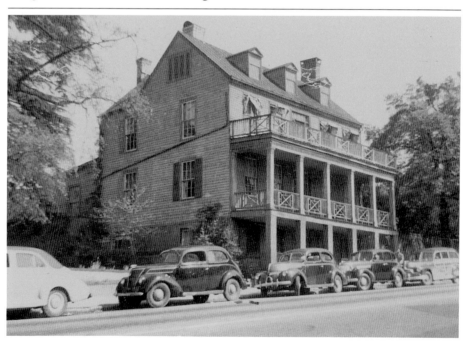

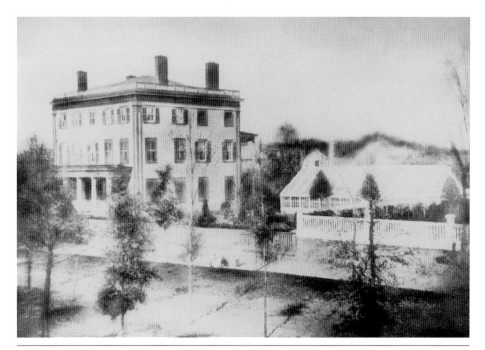

Edward Kidder, a local shipping magnate, came to Wilmington from Boston in November 1826. His New England–style house at 101 South Third Street, pictured above *c*. 1860. sat on a double lot that ran all the way from Third to Fourth Street. The Kidder family eventually owned Kendal and Lilliput plantations in Brunswick County. Today a two-story law office sits at the corner of Third and Dock.

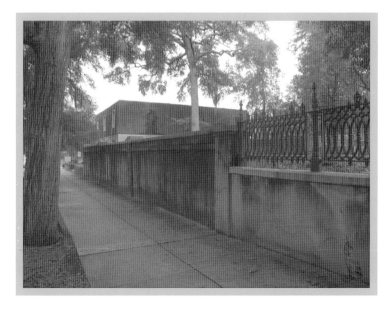

Wholesale grocer Rufus William Hicks built the turreted house at 418 South Third Street in 1889. The 16-room residence, constructed from a plan in *Scientific American*, featured granite trim, a slate roof, two Tiffany chandeliers, parquet floors, and many stained glass windows. Hicks's wife, Sallie, conducted the first meeting of the North Carolina Sorosis here in 1895. Today a group of condominiums sits on the site. (Mary Carr Fox.)

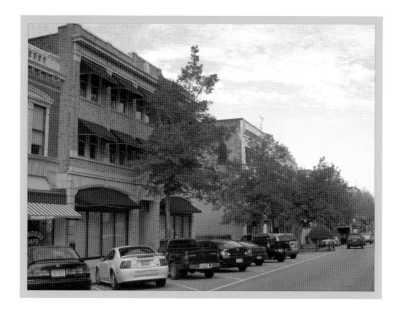

Robert H. Cowan, who lived at 213 North Front Street, was an original shareholder and director of the Wilmington and Weldon Railroad, organized in 1836. His residence, pictured below c. 1880, eventually became an office of the Central Carolina Railroad. The building was torn down in 1910 and replaced with the Bijou Theater, which occupied the empty lot in the photograph above.

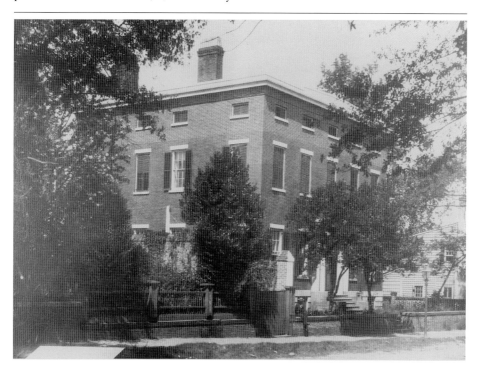

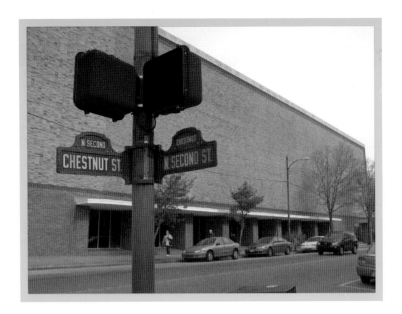

The 1943 photograph below shows the Dr. Thomas Fanning Wood House on the northeast corner of Second and Chestnut Streets, which had a doctor's office on the first floor and a residence upstairs. The house was destroyed in the 1950s and the iron fence moved to a private residence at 2514 Oleander Drive. Belk-Beery, Wilmington's flagship department store of the 1950s, was built in its place. Later, after the store moved to Independence Mall, the building became the New Hanover County Public Library.

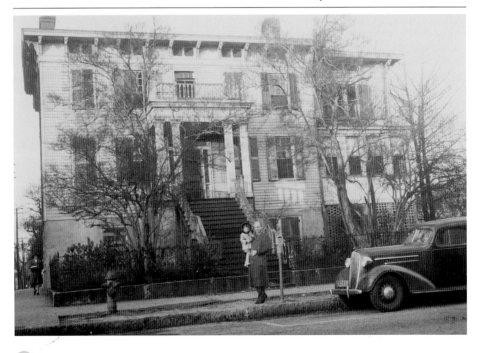

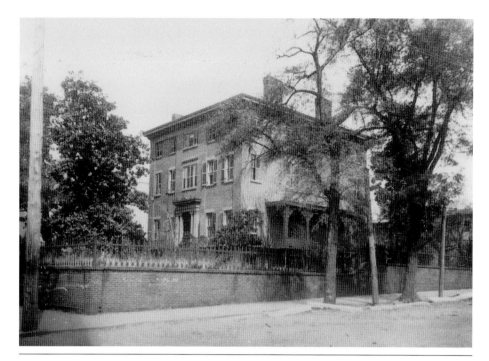

The Platt K. Dickinson House at Front and Chestnut Streets was built in 1851. Pembroke Jones, the most famous occupant of this house, was three months old when his mother, Jane Lord Jones, died in 1859. His maternal aunt, Mrs. Alice Lord Dickinson, raised her nephew and with her husband eventually bequeathed their estate to Pembroke Jones. The house was demolished in 1900 to make way for the three-story Murchison Bank Building, which still sits at 200 North Front Street.

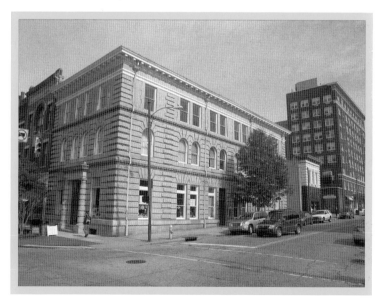

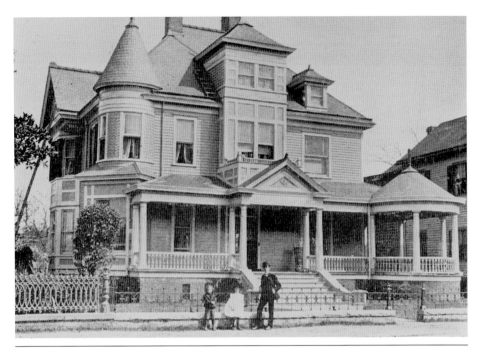

In 1885, Robert Rankin Bellamy opened a drugstore on the northwest corner of Front and Market Streets, where he sold primarily wholesale medicines and marketed "double distilled extracts for the ladies." The downtown building, still owned by R.R. Bellamy's descendants, presently houses Toms Drug Store. In 1895, Robert Bellamy built the house above at 509 Market Street, next door to his parents' house, the Bellamy Mansion. The Robert Bellamy House burned in the 1980s. The space now serves as a parking lot for the Bellamy Mansion Museum. (I.J. Isaacs. *Wilmington Up to Date*, 1902.)

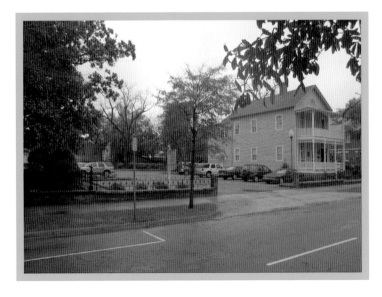

Judge Joshua Grainger Wright built the house below at his Mount Lebanon estate *c.* 1800. Lincoln Memorial architect Henry Bacon may have designed exterior changes executed *c.* 1912 under Latimer family ownership. The Rebecca Laymon residence at Bradley Creek Point now occupies the actual site of the old house, but the original name lives on in Mount Lebanon Chapel, located within Airlie Gardens.

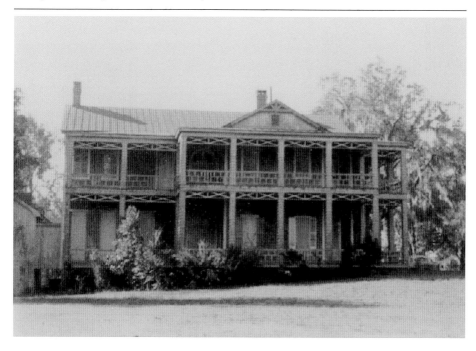

New owner John D. Bellamy Jr. commissioned drastic alterations for the Wright-Harriss-Bellamy House at 603 Market Street about 1898. Louis Henry Vollers served as contractor for the changes. Vollers's great-neice Norma Gravenstein remembers family stories about the days Vollers spent "building a new house around an old house" and adding a "German helmet." The house burned in 1972 and was demolished in 1973. Today a law office sits in its place.

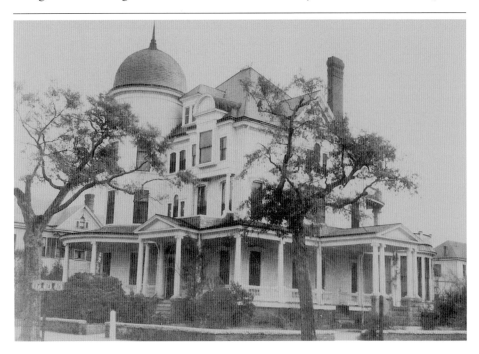

The house on the southwest corner of Fifth and Orange Streets took its name from its most famous owner, General Alexander MacRae. Though often called away, MacRae and his eight sons made this house home base during the Civil War. A wooden room, a portion of which can be seen in the photograph at right, adjoined the kitchen and was home to the "Queen of Mondigo," a slave who received special privileges in the MacRae household. The Alexander MacRae House was razed mid-20th century and an office building has replaced it.

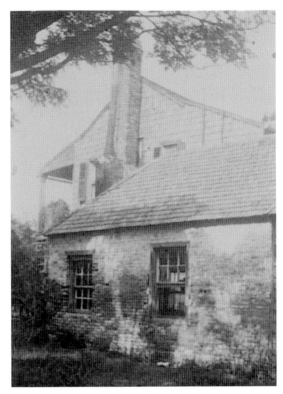

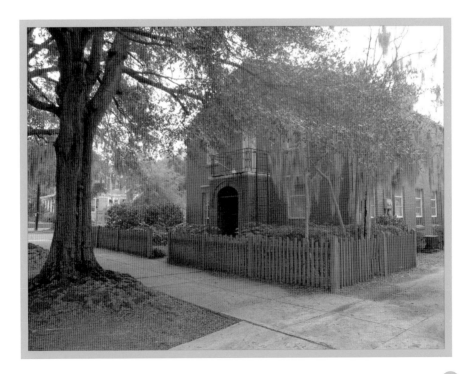

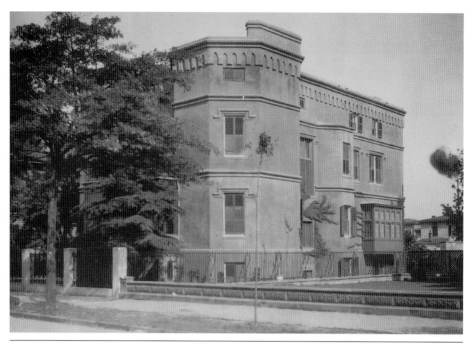

Designed by James F. Post, the Wood-MacRae House at 713 Market Street was built for John Coffin Wood in 1853. Donald MacRae, son of General Alexander MacRae, purchased it in 1859. The majority of the castle's Scottish effects were designed about 1902 by architect Henry Bacon for Donald's son, Hugh. The castle was torn down in May 1955. Today a government building occupies the land. (Calder Collection.)

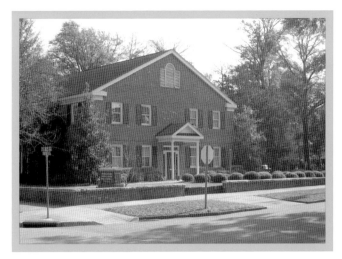

Attorney and renowned orator Joshua Grainger Wright Jr. lived in the house at 603 Market Street from about 1846 until his death in 1863. The first bathtub in the state, a lavish copper and oak affair, was installed here in 1850. Joshua Wright Jr. married a distant cousin, Mary Ann Walker, a descendant of Sir James Alexander Wright, a Colonial governor of Georgia. But one of Mary's cousins is more famous today: Anna McNeill Whistler, better known as "Whistler's Mother." (North Carolina Collection, University of North Carolina Library at Chapel Hill.)

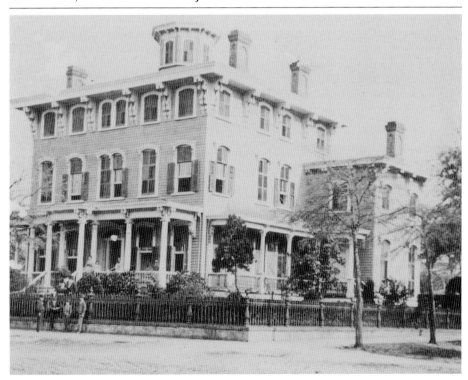

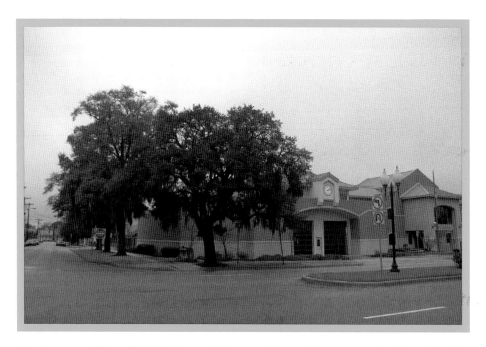

The home of John H. Rehder and his wife, Elise Bissinger Rehder, was on the northeast corner of Eighth and Market Streets. Guests at their annual New Year's Eve party could dance to the music of an orchestra in the third floor ballroom, descend to the second floor to play billiards in the handsome game room with bleachers, or relax in the parlor surrounded by Rehder's medieval armor collection. Handsome grounds and a first-floor greenhouse seemed natural, considering that Rehder was brother to Will Rehder, who operated North Carolina's oldest florist. Today the attractive Wilmington Fire Department Headquarters building occupies the spot.

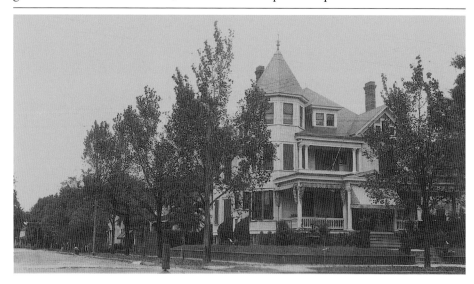

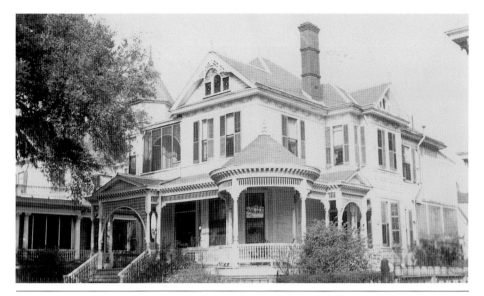

Emmanuel Israel Bear was born the day the Temple of Israel was consecrated, May 12, 1876. The *c.* 1930 photograph above shows E.I. Bear's residence at 114 North Fifth Street, near the southeast corner of Fifth and Chestnut Streets, next door to Barbara Bear's home. The Bear family was involved in many business ventures including wineries that utilized grapes and berries grown by farmers throughout southeastern North Carolina. Sadly, today this is just one more example of "putting up a parking lot."

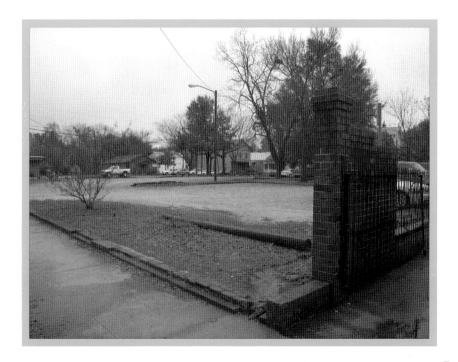

Once the residence of F.A. Thompson, the house at 109 North Fifth Street had been sold and converted into apartments by 1942. A housing shortage during World War II led to many such makeovers when soldiers and shipyard workers flooded the town. A BellSouth building now occupies this spot.

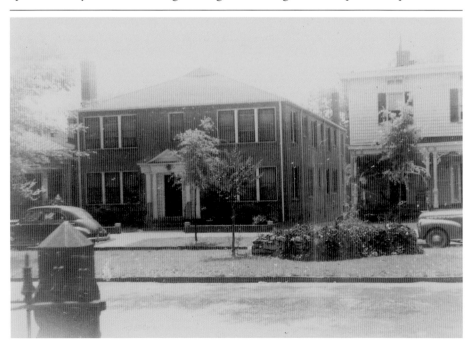

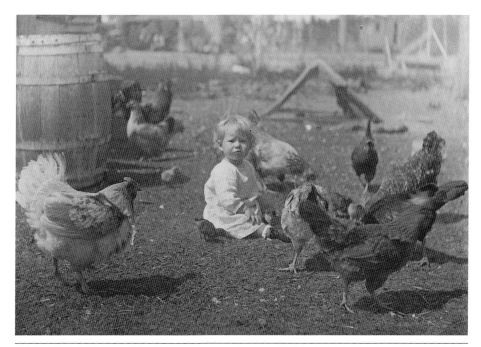

Not too long ago, you did not have to be a farmer to have livestock in your yard. Backyard chicken coops provided many a Wilmingtonian with fresh eggs and Sunday dinner roasters. In this 1912 scene, Jane MacMillan sits with feathered friends at the corner of Wrightsville and MacMillan Avenues in Winter Park. In 1931, Jane MacMillan married Wilmingtonian Laurens Wright, who became CEO for Standard Oil in the state of North Carolina. Though the Winter Park house is gone, the MacMillan's downtown residence at 118 South Fourth Street survives.

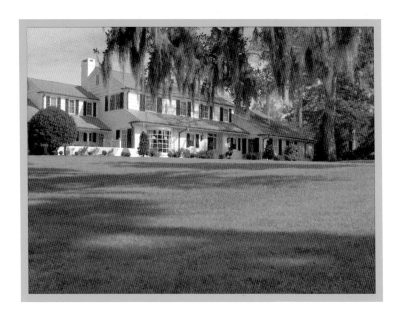

The photo below shows only a glimpse of Sarah and Pembroke Jones's 39-room house at Airlie. Handsomely appointed, and boasting a third floor ballroom, the mansion was the scene of some of the South's grandest parties. A huge challenge to maintain under normal circumstances, the house was demolished by new owners Bitsy and Waddell Corbett in the 1950s and replaced with the Spring Garden Road residence seen above. The house in now occupied by Mr. and Mrs. Milton Schaeffer Jr. (North Carolina Division of Archives and History.)

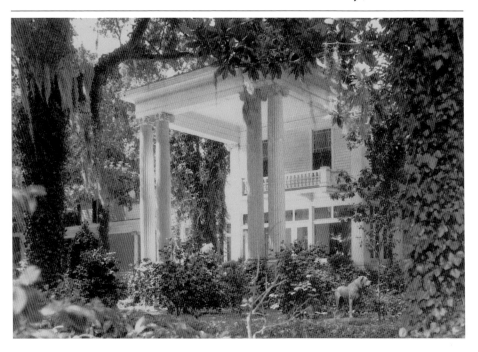

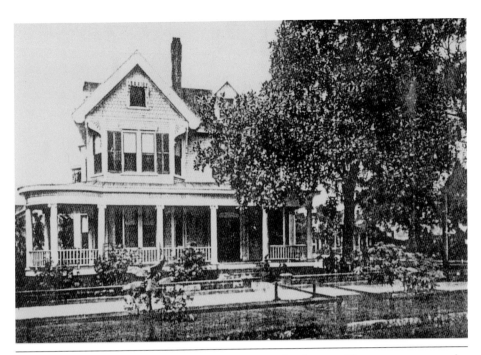

The Swann-Weathers House at 117 North Third Street was disassembled in 1922 and moved to 1405 Airlie Road, where it was rebuilt. Descendants of C.M. Weathers, Robert McCarl, James McCarl, and Mary M. Wilson still own the house. The property on the southwest corner of Third and Chestnut Streets became part of MacMillan and Cameron. Today the local headquarters of BB&T Bank dominate the corner. (Below photo by author.)

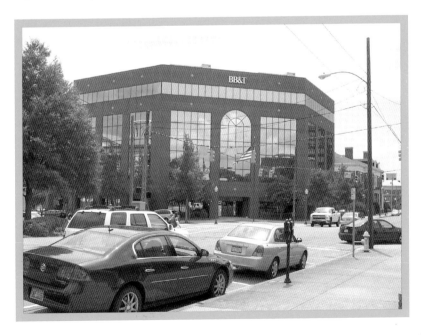

After the death of his first wife, John Burgwin began to call his country home "The Hermitage." Burgwin family members continued to live there for the next 100 years, eventually subdividing a portion of the property. On March 31, 1881, The Hermitage burned to the ground. The painting below is based on a sketch by Eliza Clitherall, Burgwin's daughter. Today the Castle Lake Estates subdivision sits on the old Hermitage property. (Above photo by Tillman Cooley; Below, Lower Cape Fear Historical Society.)

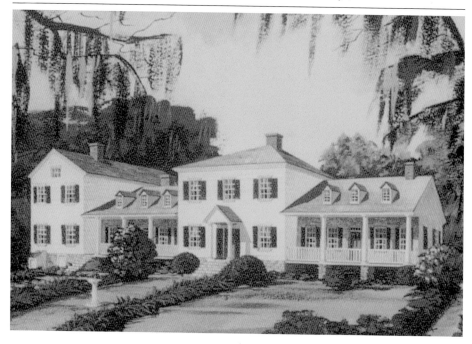

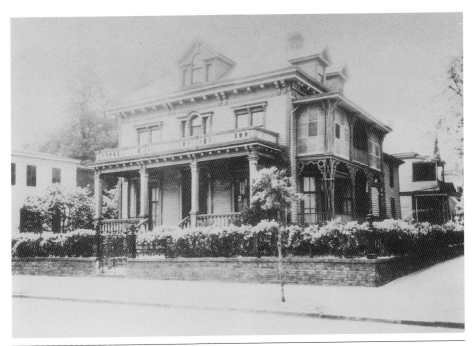

John Dawson's house once graced the "other corner" at Fifth and Market Streets, across from the Bellamy Mansion. It was "a model of architectural taste and skill," according to the *Wilmington Herald*. Dawson, a cousin of New York's merchant prince A.T. Stewart, was a local retailer who used his connection to Stewart and to local railroad officials to thrive as chief supplier of rail building materials. The house, built with the finest materials available, was razed to make room for the one-story office below. A pink marble mantel from the house now graces the den of a residence at 218 Forest Hills Drive.

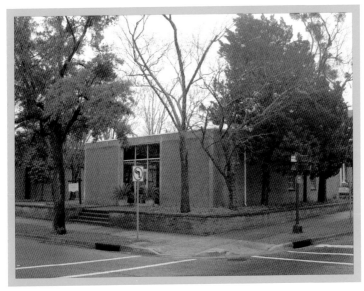

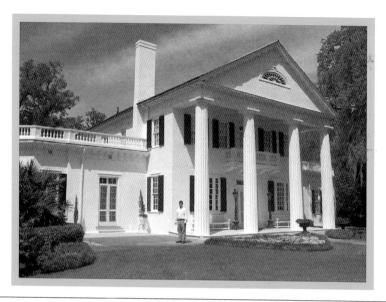

Orton Plantation owner Col. Kenneth Murchison, pictured below *c.* 1890, was a New York businessman who treasured the solitude of his Brunswick County tract. The original dwelling was built by Roger Moore about 1735 and still exists at the core of the present Orton residence. James Sprunt, cotton exporter, historian, and philanthropist, married Col. Murchison's daughter Luola and oversaw expansion of the house. Above, Col. Murchison's great-great-grandson David Harriss Sprunt stands before his family's preserved mansion. (Courtesy Allison Breiner, *Wrightsville Beach Magazine*.)

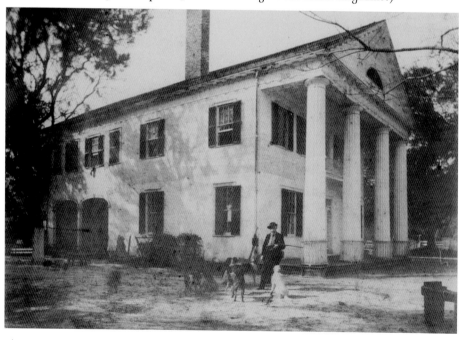

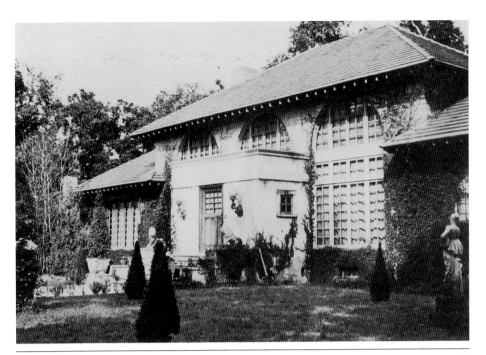

Around these parts, the phrase, "Keeping Up With the Joneses" specifically means emulating the lifestyle of Sarah and Pembroke Jones. The "Bungalow," as Jones always called it, was an elegant Italianate hunting lodge designed by painter, novelist, and architect J. Stewart Barney. Sadly arsonists burned the Bungalow in 1955. Today, a new house is going up on Landfall's Great Oak Drive, on the lot pictured below—one of three parcels that accommodated the famous getaway and its terraces. Within shouting range, two original structures survive: the Temple of Love, designed by John Russell Pope; and the oyster roast, used in Jones's era for mid-day feasting.

In 1910, with no Internet chat rooms or television, the front porch was a social gathering place. Members of the Robert H. Bowden family are pictured below at their home at 415 Princess Street. Comfortable furnishings and those downtown breezes turned porches like this into extra rooms where communication took place face to face. Ironically, this string of fine old houses was destroyed to build a large telephone headquarters building.

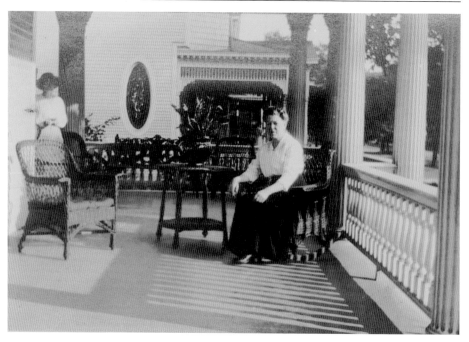

CHAPTER 3

BUSINESS AND INDUSTRY

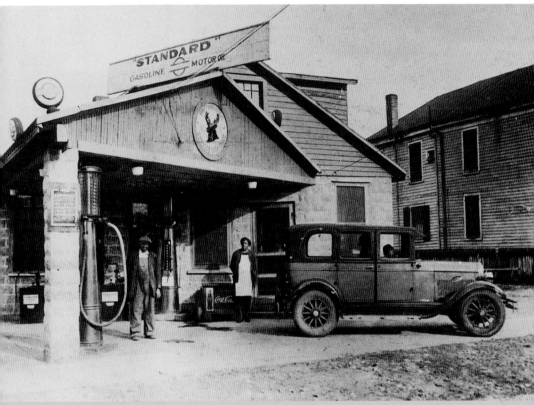

Hard work and ingenuity usually bring blessings no matter what the challenges. If you consider origins, commercial Wilmington is a montage of fortunes. The Bank of Cape Fear, the "Smithsonian" (pictured here), MacMillan and Cameron, the Atlantic Coast Line railroad, Champion Compress, and a host of other local success stories all thrived on labor and good thinking. Today the gleaming new PPD headquarters building stands as a reminder that Wilmington is a great place to do business. (Photo of Hubert and Mabel Smith's business from *Along the Cape Fear*.)

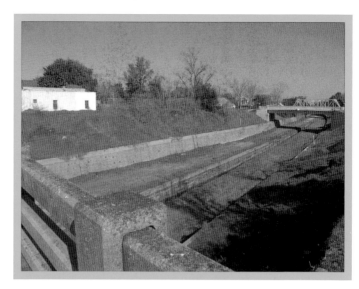

As headquarters for the Atlantic Coast Line, Wilmington was once centered in a web of rails and a network of imposing office buildings. In 1960, the railroad itself departed the station for new headquarters in Jacksonville, Florida. Wilmington's fledgling industrial development agency, the Committee of 100, brought new businesses to town, but nobody bet on the future value and usages of the old ACL structures. Most railroad buildings were decimated.

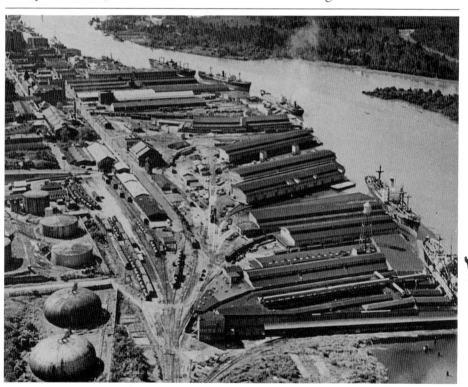

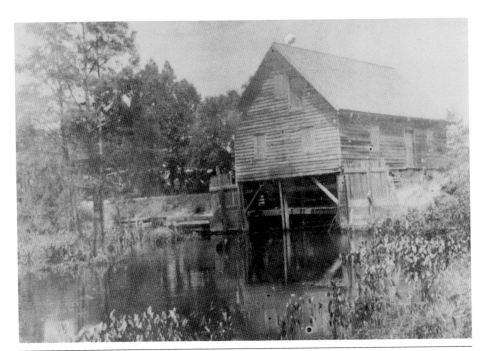

In the eighteenth century, Greenfield Lake was "Greenfields," the home of Dr. Samuel Green. The old mill still stood in the late 1800s, and was located where the spillway now flows. Public Works Commissioner J.E.L. Wade, Sallie Hicks, and others recognized the potential of the old plantation and led a campaign for its beautification in the 1920s and 1930s. Today Greenfield is experiencing a rebirth, with "green" being the operative word.

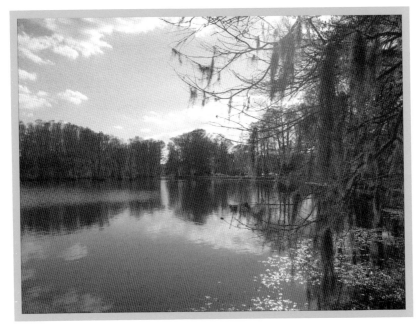

The three-story house that once stood on the northwest corner of Third and Market was built by Armand John deRosset, a physician who was still practicing in 1857 at the age of 90. The house once sported handsome second floor balconies that sat over wide first floor porches. Despite pleas to save the house, it was torn down. A series of businesses have sat on the prominent corner since then. In 1972, the Harold Wells and Son Insurance Company took residence at 1 North Third Street.

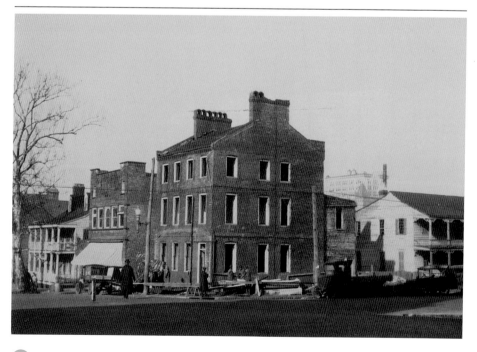

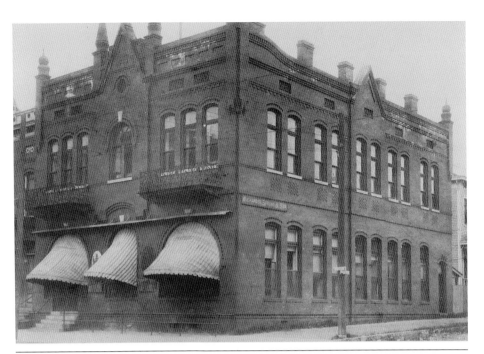

The general office building of Alexander Sprunt and Son was built on the northeast corner of Front and Walnut Streets, a site laid vacant when the Front Street Methodist Church burned in 1886. Within months, construction began on this brick building. Later, it was utilized as the Shamrock Cafe and the Parker Seed Company. Now Cape Fear Community College fills the landscape. Over 26,000 students currently attend the school and the list of full-time employees tops 400. (Duke University, Special Collections Library.)

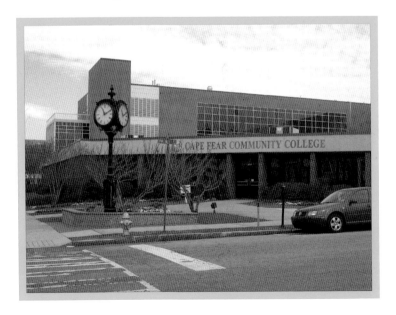

Harper Sanitarium, on the northeast corner of Front and Castle Streets, was founded by Dr. Charles T. Harper and was built for $7,500. The first floor was divided into two storefronts. The second floor contained 12 rooms, one of which was used for surgery. Later, the building housed Southside Pharmacy. Today the space is simply a vacant lot, but maybe not for long. Solomon Towers, a neighboring riverfront high rise, is currently scheduled for massive upgrades.

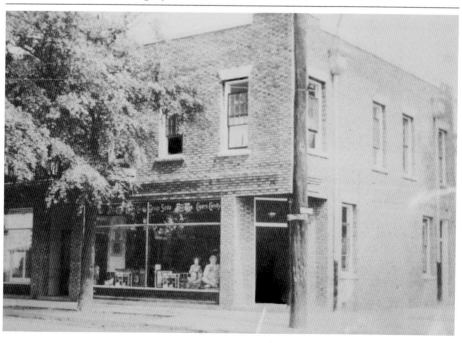

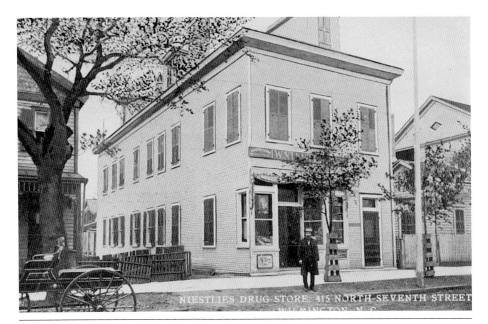

NIESTLIES DRUG STORE. 415 NORTH SEVENTH STREET
WILMINGTON, N. C.

Pictured above is Niestlie's Drug Store at 415 North Seventh Street as it looked c. 1900. William Niestlie, a pharmacist, manufactured drugs and sold them from his house. In 1920, Dr. Foster Burnett, a physician, bought the building and transformed it into the first Community Hospital. In 1938, the hospital moved to new facilities and this building later was razed. The dental office of Dr. Suzette Gause and Dr. Roger Gause has now replaced it.

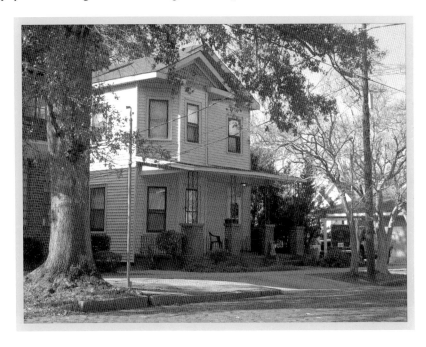

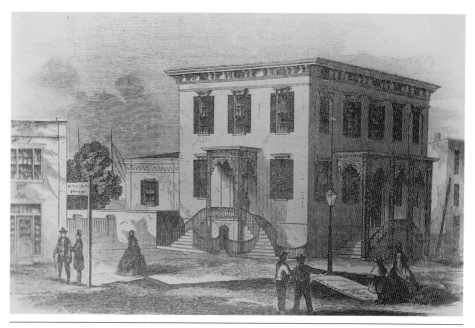

Tradition states that the Bank of Cape Fear building at 17 North Front Street was once the home of merchant John Ancrum, who died in 1779. Bank president Joshua G. Wright purchased the property in 1806. The bank dissolved after the Civil War and the building was razed in 1899 to make room for the Masonic Temple, which still stands but is now an assortment of privately owned condominiums. Performances are still held in the old fifth-floor theater, now known as City Stage.

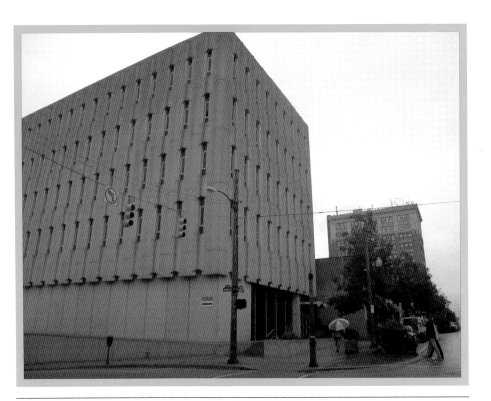

The Bank of New Hanover was incorporated in 1872 and this office on the northwest corner of Front and Princess Streets was built by April 1873. After 1902, a series of different banks occupied the building, including the Atlantic National Bank of Wilmington, the National Bank of Wilmington, and the People's Bank. It was demolished in 1959 to make way for the Wachovia Bank building, which is currently scheduled for demolition.

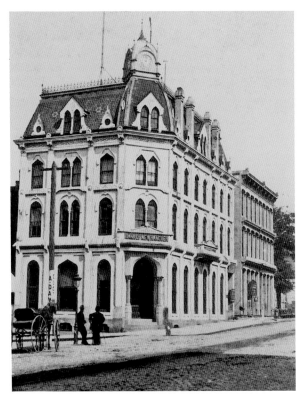

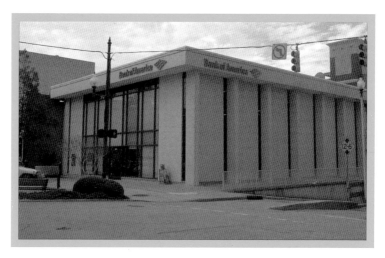

The Southern Building, owned by Matt Heyer and designed by Charles McMillen, sat on the southwest corner of Front and Chestnut Streets and housed an array of offices. A Bank of America building currently occupies the corner.

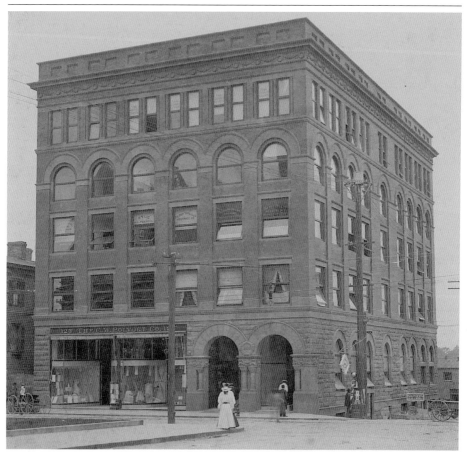

The Carolina Insurance Company building stood at 10 Princess Street and seemed to draw some of its elements from the 1889 U.S. Post Office. The photo to the right was taken in 1916 as workmen readied the site for the present U.S. Custom House. Splendid in size, style, and building materials, the new federal building was probably made possible by U.S. President Woodrow Wilson's close ties to the port city. Wilson, whose father was minister at First Presbyterian Church, lived in Wilmington in 1875 and 1881. (Below photo by author.)

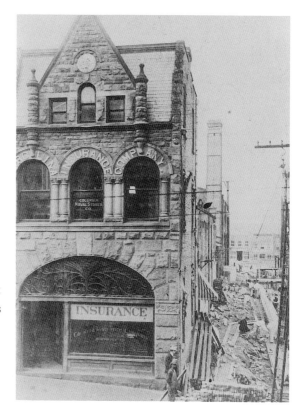

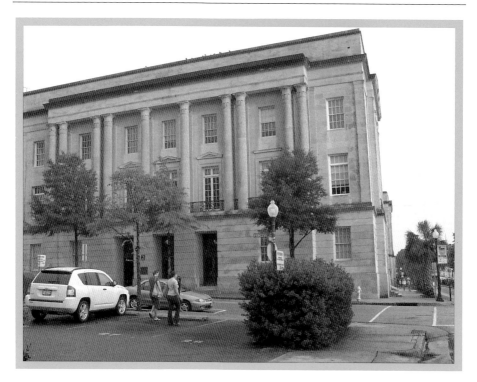

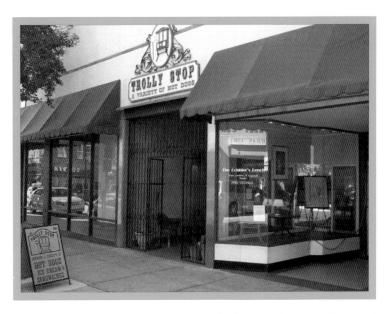

In addition to the Orton's long run as a luxurious hotel, it also served as an apartment house during its latter decades. Elisabeth Chant, founder of Wilmington's 20th century art movement, lived at the Orton in 1922. She conducted meetings of her newly formed group, The Art League, here for several years. Renowned clothiers and clothing designers Bessie Buck and Beulah Meier also lived at the Orton. Meier helped give the Azalea Festival style and grace in its early years. Today the wildly popular Trolley Stop marks the northern boundary of the hotel that once served "Gelee au Vin de Champagne."

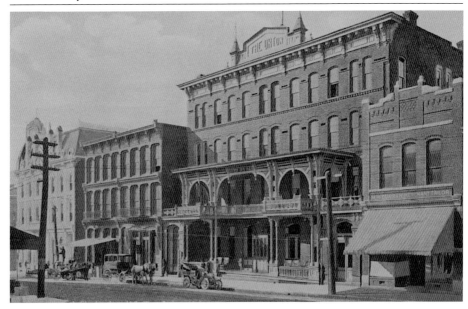

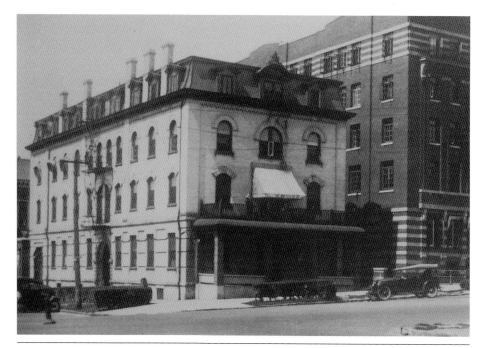

The Colonial Inn, owned by Oscar Pearsall, occupied one of the best corners in town: the northeast corner of Third and Market Streets. Pearsall and his brother Philander were wholesale grocers with partner Benjamin Franklin Hall. In 1903, Oscar Pearsall moved a two-story frame residence and replaced it with the apartment building pictured in this *c.* 1920 photograph. The Colonial Apartments burned on April 25, 1962. Today the camera catches a much different sight. The artful W. Allen Cobb Judicial Annex, designed by BMS Architects PC, was completed in 2002—and does wonders for the perfunctory parking lot.

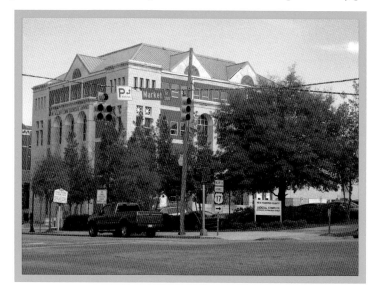

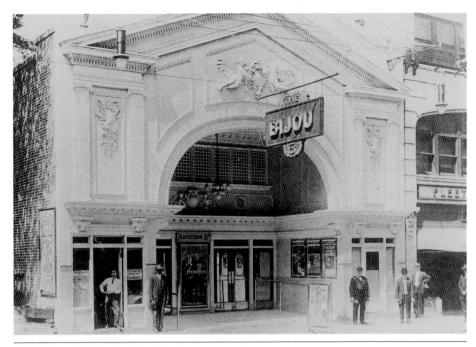

J.H. "Foxy" Howard and Percy Wells formed a partnership in 1906 to start the first motion picture theater in the state. After a successful three-night stint at the Academy of Music, known today as Thalian Hall, they moved their business to 211 North Front Street, where they set up a 200-foot-long carnival tent capable of seating 500. Wilmington native E.V. Richards Jr. worked at the Bijou in 1906, then went on to become a co-owner of Paramount Pictures and Saenger Theaters. The marquee and the old peanut roaster, housed at Cape Fear Museum, are all that are left of the old Bijou.

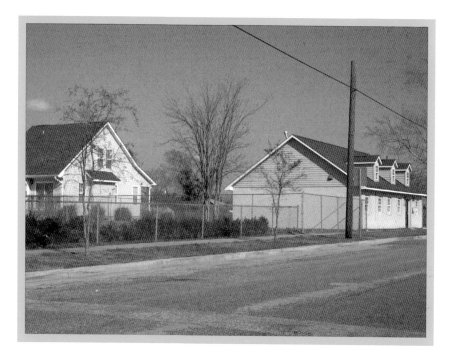

During the 1930s, the Emergency Relief Administration operated a mattress factory in Levi McKoy Moseley's building at 615 Nixon Street. Sixteen women, including Mr. Moseley's daughter Margaret Williams, assembled mattresses for the needy. Levi Moseley's sister, Augusta Moseley Cooper, was a noted Wilmington leader and historic preservationist.

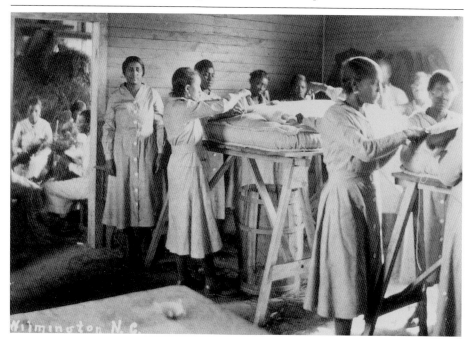

Architect Charles McMillen designed the Odd Fellows Building on the northwest corner of Third and Princess Streets in 1904. Waccamaw Bank bought the property and tore the building down in 1967, not long after the photograph below was taken. Originally, a third-floor passageway on the north side of this building connected it to the College of Physicians and Surgeons next door. Today the RBC Centura bank headquarters sit on the corner of Third and Princess Streets.

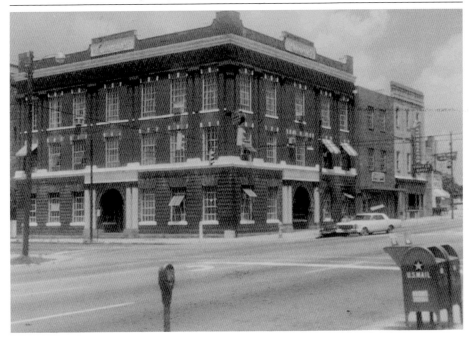

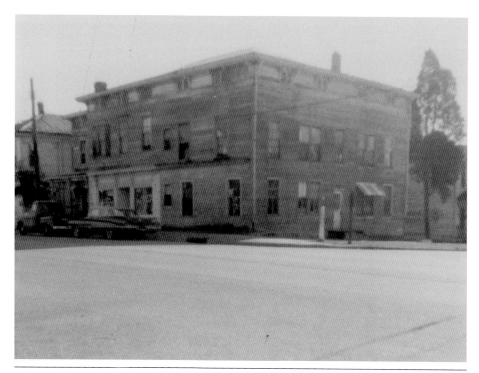

Handsome in its day, this turn-of-the-century building on the southeast corner of Fourth and Castle Streets was looking frayed in 1963 when this photograph was taken. Originally home to Melchior George Tienken's "Palace Variety Store," it became William B. Beery Dry Goods in 1915; the local company eventually evolved into the present 20-store chain known as Belk-Beery.

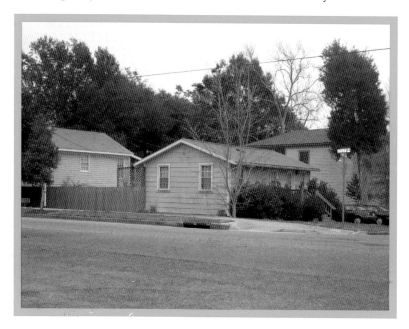

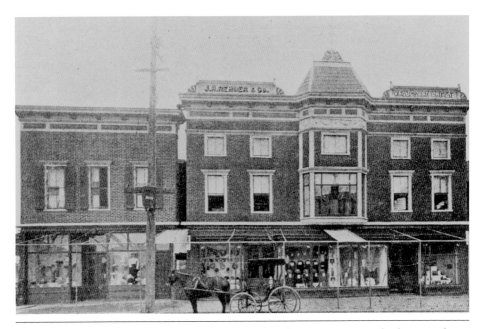

The J.H. Rehder Company was established in 1887 and thrived until the Great Depression. Located at 617 North Fourth Street, it supplied customers with everything from fancy hats to carpets. The above photograph was taken in 1902, which was about the time John Rehder began a highly successful mail order program. Today North Fourth Street is part of a trendy new artistic movement—and a business revitalization.

Buildings of
Substance

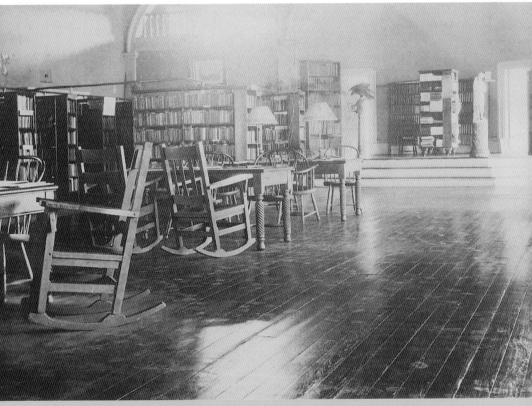

Over time, we often feel a special sense of connection when it comes to certain buildings. Schools, churches, federal buildings, and clubs can conjure up a sense of ownership—and rightly so at times. Taxpayers help build and maintain post offices and schools. Memberships and assessments help build clubs. And church members have underwritten much of what we see beneath the steeples of downtown Wilmington. But many of us feel that we are threads in the fabric of such institutions, if only by virtue of familiarity. (Photo of the Wilmington Public Library c. 1930, from *Along the Cape Fear*.)

The post office was moved from the old customhouse on Water Street to 152 North Front Street on June 4, 1889. W.A. Freret, supervising architect of the U.S. Treasury, designed the new building. Two faces sculpted of concrete peered out from the wall, one smiling and one frowning, to represent the emotions mail can bring. But there were a lot more frowns than smiles in 1936 when the grand old building was dismantled to make way for one with much less character.

In 1768, services for St. James (Episcopal) Church began occurring regularly in the building pictured below. Made of handmade brick and imported glass, it sat partially out in Market Street between Third and Fourth. The building was abutted by graves, some of which still sit under the street. This watercolor may have been painted by Thomas U. Walter, architect of the U.S. Capitol dome — and the Gothic Revival building that replaced the Colonial Church in 1839.

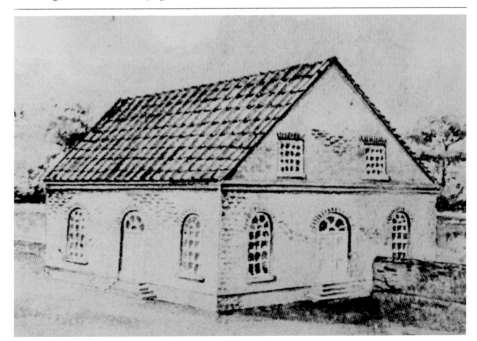

By 1851, the congregation of St. James had already outgrown its new building and bought a lot for a second church at Third and Red Cross Streets, a location considered promising because of its proximity to the Wilmington and Weldon Railroad. St. James supplied $15,000 in building funds. Work began on St. John's on November 21, 1853. In 1955, the congregation of St. John's began worshipping in a new building at 1219 Forest Hills Drive in which the windows, memorial plaques, and pipe organ from the old structure were incorporated.

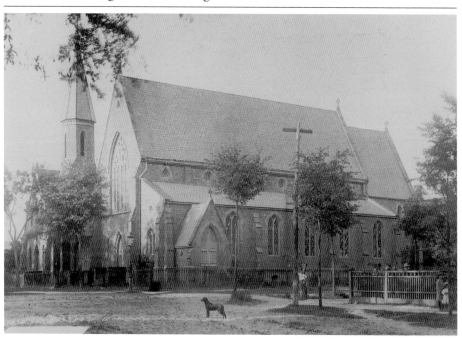

The photo on the right depicts the third building erected by First Presbyterian Church. Designed by architect Samuel Sloan, the building was dedicated April 28, 1861, and the total cost of construction was $20,000. During the building's lifetime (1861–1925), revivals and several ministers led the congregation to give unprecedented fortunes to church-related mission causes. The present building, a Gothic Revival stronghold designed by Hobart Upjohn, cost about $500,000 in 1928. Today it is literally irreplaceable.

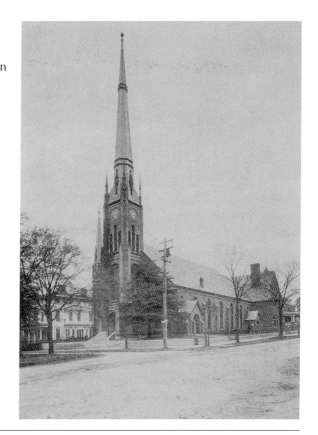

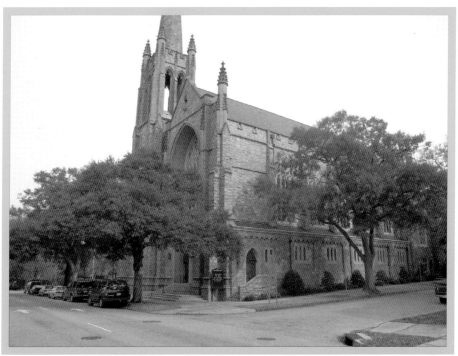

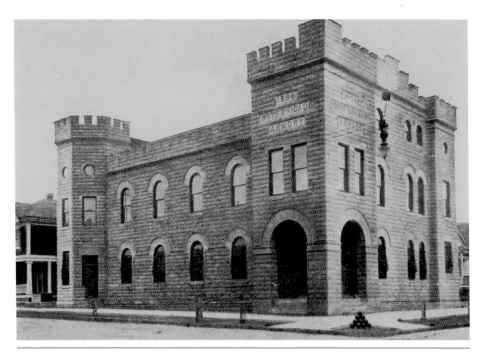

The Boys' Brigade met in the basement of Immanuel Presbyterian Church from 1896 until the new armory (above) was dedicated June 22, 1905. The Norman structure on the southeast corner of Second and Church Streets was a gift from Mary Lily Kenan Flagler. The Boys' Brigade Armory moved to a new home in 1950 and the building was sold, then razed *c.* 1960. During the late 1980s, houses were built on the site. Deep underground, compressed remnants of the old basement remain.

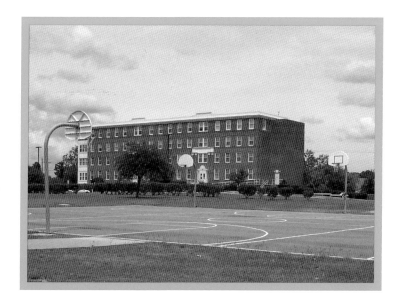

James Walker Hospital was a footnote to vital statistics for Wilmingtonians from 1901 until 1967. The hospital, located at 10th and Rankin Streets, served many segments of local folk, but the most privileged often had their maids and butlers bring them dinner, along with fine china and sterling flatware from home with which to eat it. As late as the 1950s, anesthesia consisted of a mask of ether descending towards a patient's horror-stricken face. Today the only James Walker Hospital complex building to survive is the nurses' dormitory (above). (Above photo by author.)

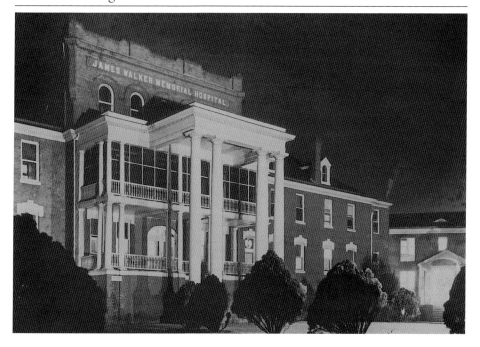

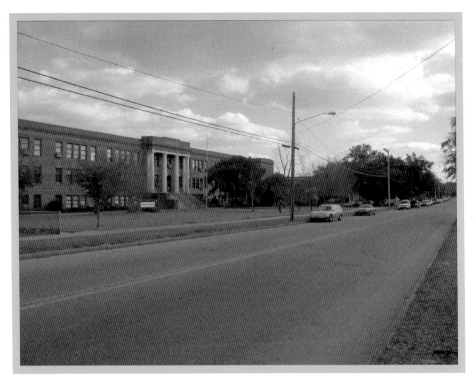

Williston High School, at 319 South Tenth Street, is panoramically pictured below as it looked in 1931. This building burned in 1936 and was replaced with a similar structure. Williston was a school for blacks prior to integration in 1968, and enjoyed a reputation for outstanding teachers. Ahead of their time, students engaged in volunteer community service—an activity continued today through the Wilmington Alumni Association. (Louis T. Moore Collection, New Hanover County Public Library.)

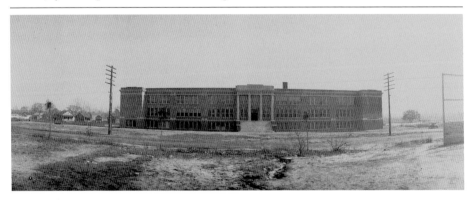

The Gregory Community Center at 613 Nun Street was built in 1881 by the American Missionary Association as a residence for teachers of the black community. Northerners, concerned with the educational needs of blacks, gave generously to the Gregory Community Center as well as to Gregory Congregational United Church of Christ, whose building still exists at 609 Nun Street.

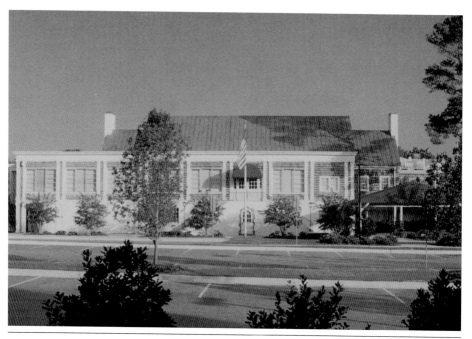

Cape Fear Country Club is the oldest country club in North Carolina. The first modest clubhouse and links were at Hilton Park in 1896. According to club historian Diane Cobb Cashman, "Ensuing club houses improved and the membership grew. The newest club house is more grandiose than the founding members ever could have dreamed and in addition offers a superb 18-hole course and magnificent tennis and swimming pool facilities."

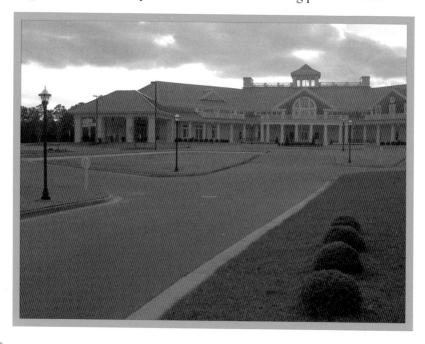

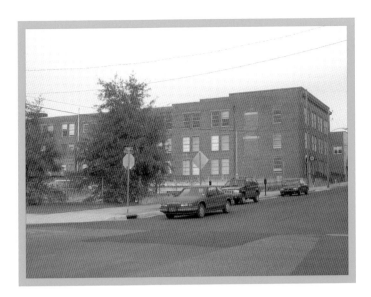

The exciting Union Station, built in 1913 on the northeast corner of Front and Red Cross Streets, was designed by Joseph F. Leitner, the official architect for the Atlantic Coast Line Railroad. Union Station was demolished July 11, 1970. However, the Freight Traffic Department, just east of Union Station, has survived. Oddly enough, its most famous employee was artist Claude Howell who, for years, was part of a stenographers' pool. Howell, along with the young ladies he worked with, sang current songs as they typed to the beat, hitting the return key in unison. Their supervisor was not amused.

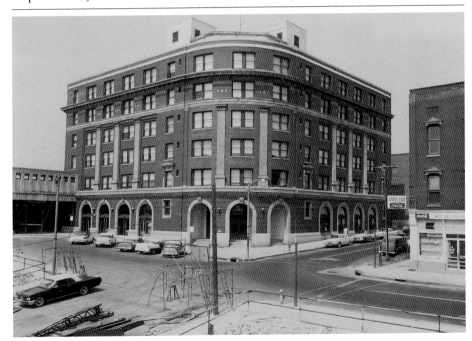

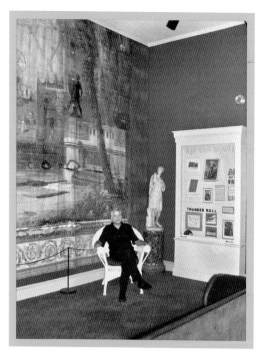

Thalian Hall, built 1855–1858, is the only surviving theater designed by renowned theater architect John Trimble. Throughout its long history, grassroots efforts have helped maintain and enhance Thalian Hall's beauty. Pictured below, local artists Henry J. MacMillan, Helen MacMillan, and William Whitehead create murals for the theater in 1939. Today, under the expert leadership of Tony Rivenbark (left), executive director and historian since 1979, Thalian Hall thrives. (Left photo by Steve Coley.)

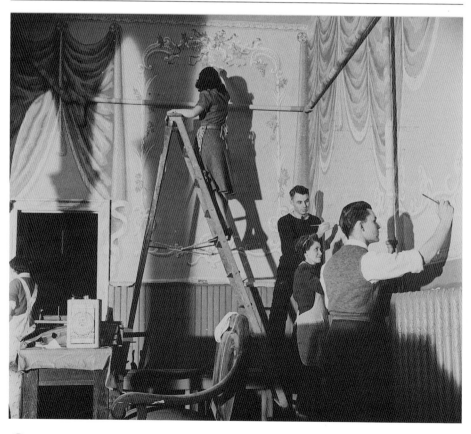

Dr. J.G. Murphy built the house at 115 South Third Street. Dr. Murphy, a member of the nearby First Presbyterian Church, was also Sunday school superintendent of the Queen Street Mission, a black church. Today the Murphy House site has been incorporated into the First Presbyterian Church parking lot.

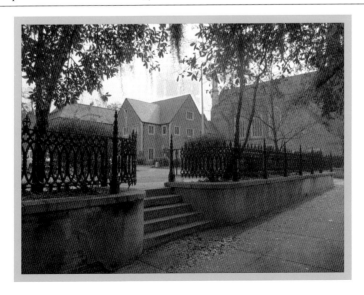

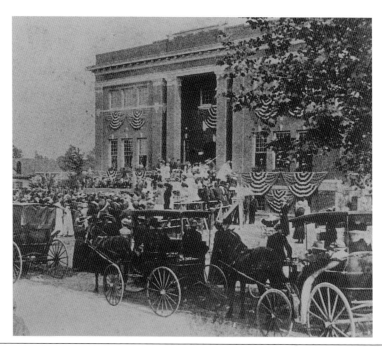

In 1911–1912, Samuel Bear built Isaac Bear School on Market Street between Twelfth and Thirteenth Streets as a memorial to his brother, who had died in 1911. The University of North Carolina at Wilmington, known at the time as Wilmington College, began in this building in 1947. When the campus later moved to South College Road, university officials named one of the new buildings Bear Hall in honor of their first home. An auditorium, pictured below from 13th Street, is all that remains of Isaac Bear School. (Below photo by author.)

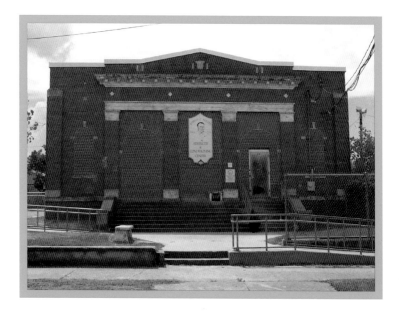

In 1857, the U.S. Treasury Department purchased 50 acres in the "southeastern suburbs" as a site for a U.S. Marine Hospital on the corner of Eighth and Nun Streets. Completed in 1860 but only opened on a limited basis, it was sold in 1870, only to be repurchased by the government eight years later. Except for occasional meetings, the building below was dormant from 1919 until its demolition in 1950. (North Carolina Collection, University of North Carolina Library at Chapel Hill.)

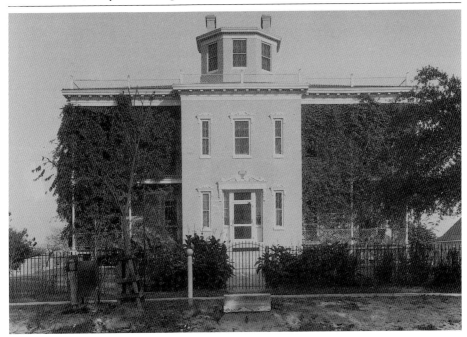

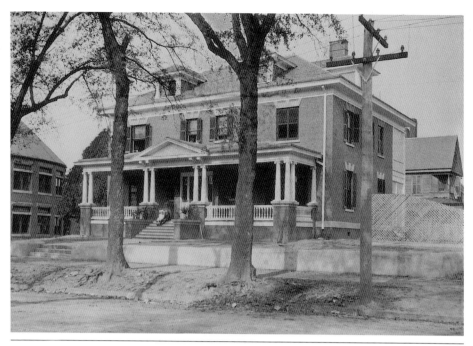

The First Presbyterian Manse at 317 Orange Street, pictured above about 1910, replaced an earlier one in which Woodrow Wilson once lived with his parents. The building on the left is Chadbourn Memorial Hall, built as a place for secular lectures, thus avoiding "any possibility of expression of laughter or applause" in the church sanctuary. Today the "Biblical garden" occupies the manse site and the 1928 Educational Building endures. (Calder Collection.)

The cornerstone of Southside Baptist Church, located on the northwest corner of Fifth and Wooster Streets, was laid June 26, 1913. The church, designed by J.M. McMichael, served its communicants for almost 60 years, but vandalism prompted the congregation to move to 3320 South College Road in 1972. Some stained glass from the Fifth Street building was incorporated into the new church. Today the site of the old Southside Baptist Church sanctuary is nothing but a gaping hole.

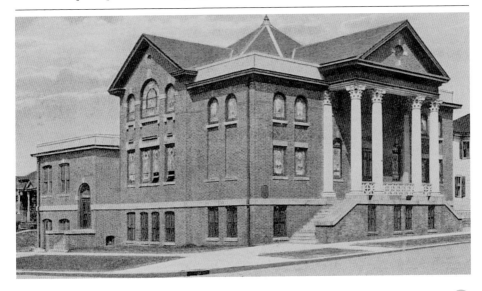

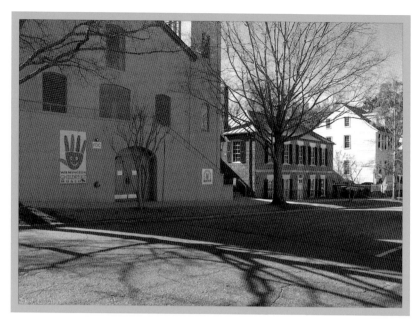

The 1805 Masonic Lodge building (center, above and below) later served as the Thomas W. Brown residence, a fancy World War II era restaurant known as St. John's Tavern, and the home of St. John's Museum of Art. In 1979, the art museum purchased St. Nicholas Greek Orthodox Church. Today both buildings on the left are part of the Children's Museum complex. St. John's Museum of Art, now known as the Louise Wells Cameron Art Museum, is now located at 3201 South 17th Street. (Above photo by author.)

Select Bibliography

Bishir, Catherine W. *North Carolina Architecture*. Chapel Hill, 1990.

Block Books and Deed Transfer Records, New Hanover County Courthouse.

Campbell, Walter E. *Across Fortune's Tracks: A biography of William Rand Kenan, Jr.* Chapel Hill, 1996.

Cape Fear Club (1967–1983). edited by Leslie N. Boney Jr. with historical sketches by James L. Allegood. Wilmington, 1984.

Cashman, Diane Cobb. *Cape Fear Adventure*. Woodland Hills, California, 1982.

—————. *The Cape Fear Country Club, 1896–1996*. Wilmington, 1996.

Evans, W. McKee. *Ballots and Fence Rails*. Durham, 1966.

Fales, Robert. *Memories of Yesteryear*. Wilmington, 1988.

Fonvielle, Chris E. Jr. *The Wilmington Campaign: Last Days of Departing Hope*. Campbell, California, 1997.

Funk, Ruth Christy. 175th Anniversary Project. Transcribed tapes: memories of First Presbyterian Church.

Hall, Lewis Philip. *Land of the Golden River, I*. Wilmington, 1975.

—————. *Land of the Golden River, II, III*. Wilmington, 1980.

How North Carolina Grew. W.P.A. Raleigh, 1850.

Howe, Samuel. *American Country Houses of Today*. New York, 1915.

Howell, Andrew J. *The Book of Wilmington*.

Hutteman, Ann Hewlett. *Wilmington in Vintage Postcards*. Charleston, 2000.

Jones, Walter Burgwin. *The Jones-Burgwin Family History*. Montgomery, 1913.

Kernan, Charles. *Rails to Weeds*. 1989.

Lee, Lawrence. *The Lower Cape Fear in Colonial Days*. Chapel Hill, 1965.

Louise Wells Cameron Art Museum Archives

Lower Cape Fear Historical Society Archives. Family files. Subject files.

MacMillan, Emma Woodward. *Wilmington's Vanished Homes and Buildings*. Raleigh, 1966.

MacRae Collection, North Carolina Collection, Wilson Library, UNC-Chapel Hill.

MacRae and Sprunt Collections. Perkins Library, Duke University.

McClure, Robert. *The Story of St. John's Episcopal Church*. Wilmington, 2003.

McKoy, Elizabeth F. *Early New Hanover County Records*. Wilmington, 1973.

McKoy, Henry B. *Wilmington, North Carolina — Do You Remember When?* Greenville, South Carolina, 1957.

Memorial of the First Presbyterian Church, Wilmington, NC (1817–1892). Richmond, 1893.

Pictorial Sketch of Wilmington, North Carolina and Vicinity. New Hanover County Library.

Reaves, William M. *Strength Through Struggle: The Chronological and Historical Record of the African-American Community in Wilmington, North Carolina, 1865–1950*. Wilmington, 1998.

—————. Newspaper Files. New Hanover County Public Library.

Russell, Anne. *Wilmington: A Pictorial History*. Norfolk, 1981.

Seapker, Janet K. and Edward F. Turberg. "Historic Architecture of the Cape Fear." Text for lecture series, 1995.

Shaffer, E. T. H. *Carolina Gardens*. New York, 1963.

Sprunt, James. *Chronicles of the Lower Cape Fear*. Wilmington, 1992.

Turberg, Edward F. *A History of American Building Technology*. Durham, 1981.

Wilson Collection, Seeley G. Mudd Manuscript Library, Princeton University.

Wrenn, Tony P. *Wilmington, North Carolina: An Architectural and Historical Portrait*. Charlottesville, 1984.

INDEX

www.arcadiapublishing.com

Discover books about the town where you grew up, the cities where your friends and families live, the town where your parents met, or even that retirement spot you've been dreaming about. Our Web site provides history lovers with exclusive deals, advanced notification about new titles, e-mail alerts of author events, and much more.

Find *Your* Place in History.